The Discoverer's Guide
Fraser River Delta
Exploring the Living River

by
Don Watmough

The publisher:
Lone Pine Publishing
206, 10426-81 Avenue
Edmonton, Alberta, Canada
T6E 1X5

Canadian Cataloguing in Publication Data

Watmough, Don
 The discoverer's guide to the Fraser River Delta

 ISBN 1-55105-014-5
 Fraser River Region (B.C.)—Guidebooks. 2. Fraser River Estuary (B.C.)—Guidebooks.
3. Outdoor recreation—Britisih Columbia—Fraser River Region—Guidebooks. 4. Outdoor recreation—
British Columbia Fraser River Estuary—Guidebooks.
I. Title
FC3845.F73A3 1992 917.11'3 C92-091430-6
F1089.F7W38 1992

Cover design: Beata Kurpinski
Editorial: Shane Kennedy, Lloyd Dick, Tanya Stewart, Gary Whyte , Doug Elves
Design: Beata Kurpinski
Layout: Charlotte Foley, Judith Bolton, Phillip Kennedy, Gary Whyte, Lloyd Dick
Maps: Victor Bodegom, Lisa Kofod
Printing: Quality Colour Press, Edmonton Alberta Canada
Special Thanks: Ken Darby, Computer Masters

The publisher gratefully acknowledges the assistance of the Federal Department of Communications, the
Fraser River Estuary Management Program, Alberta Culture and Multiculturalism and the Alberta
Foundation for the Arts in the production of this book.

For more information on the
Fraser River Estuary Management Program,
contact the FREMP office at:

Suite 301, 960 Quayside Drive
New Westminster, B.C.
V3M 6G2
(604) 525-1047

FREMP

ACKNOWLEDGEMENTS

I've always been attracted to rivers. There is some kind of archetypal attraction that draws me to moving water. The first to introduce me to the Fraser River were Richmond natives Will Paulik and Harold Steves - two dedicated environmentalists who even 20 years ago recognized the treasures that shone through the river's muddy waters. My first publications about the river were published through the Richmond Nature House. I spent much of the last decade sailing abroad, exploring the world's oceans while the river flowed relentlessly on.

When I returned from my oceanic hiatus, I again became involved with the Fraser River, working with Bruce McGavin on developing a vision and conceptual framework for improving recreational awareness of the Fraser. Mike McPhee and Leslie Brown were instrumental in getting proposals past the conceptual level. Rick Hankin of the GVRD Parks Department chaired the Recreation Committee of the Fraser River Estuary Management Program (FREMP) and guided the work through its early stages. When I rejoined the staff at GVRD, Donna Underhill took over the recreation plan, and met with municipal leaders to convey the concept. When it became clear that there was a great deal of interest in compiling the vast amount of information we had accumulated into a usable field guide, the association with Lone Pine Publishing began. Kathy Lauriente conducted much of the original field work and wrote a preliminary draft. Assisting me on field checks were Lolita Chevalier and Maralynn Holkestad. GVRD Parks staff reviewed parts of the draft and provided many useful comments. Many of the photographs used in this guide were provided by GRVD Parks staff. I am grateful for the extra effort of Lisa Kofod and Volker Bodegom in producing the maps for this book. Wendy DaDalt succeeded in getting me into a kayak at Widgeon Slough. Al and Jude Grass helped to ensure that the species information was reasonably accurate. The Lone Pine staff, especially Shane Kennedy, have been particularly supportive in this endeavor. To all of these people, and others who have inspired this work, I owe my thanks.

—*Don Watmough*

ABOUT THE AUTHOR

Don Watmough is an established West Coast author and recreation consultant.

He holds a degree in Marine Biology from Simon Fraser University, and has written extensively on sailing in the Vancouver area. In 1984, he wrote *West Coast of Vancouver Island*, a recreational cruising guide to boating in the area.

After returning from a world-wide sailing trip, he became involved in recreation planning for the Fraser River estuary with the Fraser River Estuary Management Program as a consultant.

Don has also been a consultant for The Vancouver Port Authority, the Greater Vancouver Regional District and the Squamish School District.

He currently works as a Park Systems Planner for the Greater Vancouver Regional District.

TABLE OF CONTENTS

MAPS

Legend

▭	Land	—·—··	International Boundary
▭	Water	= =	Tunnel
▱	Marsh	∿∿	Rock Wall
▭	Indian Reserve	——	Pier, Dock
▭	Park	**P**	Parking
▭	Golf Course	⛵	Boat Launch
∿	Stream or River	Beach	Site of Interest
——	Freeway	▭	Special Feature--Large Area
——	Road		
- - -	Trail	⬆N	True North
┝━┿━┥	Railway	└─┘ 1 km	Scale (Approximate)

SYMBOLS

 Walking/Hiking

 Fishing

 Cycling

 Beach Activities

 Horseback Riding

 Boating

 Picnicking

 Canoeing

 Historic Site

 Windsurfing

 Nature Study

 River Traffic Viewing

 Wildlife Viewing

 Air Traffic Viewing

 Kite Flying

 Industrial Viewing

 Shopping

THE LIVING RIVER

The Fraser is a working river. Tugs, booms, freighters and scows pass pleasure boats in unconcerned objectivity, performing their work as they always have, with the river as their highway.

The Fraser is also a living river. There are fish and birds in quantities that dwarf even human numbers. We share the river with them, and we all call it home. We have taken residence on the edge of this fluid collection of water, silt, flotsam and jetsam. Permeating all this is a sense of history- an unescapable feeling of deja vu that grabs you when you venture to its banks. This guide encourages you to do so. Visit its shores and celebrate its vibrant history, inspiring presence and emerging future. Here recreation is the adventure of exploring the river's wonders. Recreation can occur in parks (the familiar passport), as well as on remote dykes, along shaded walking trails, and at secret fishing bars, which are revealed in this guide. In addition, there are other interesting windows on the Fraser you may have never looked through. This guide is a treasure map showing where some of these windows are. It is not an exhaustive inventory of each and every recreation site, but more of a menu of opportunities, including appetizers, side orders and desserts that complement the more well-known main courses. Not all of the sites included in this guide are on public lands. Please respect the rights of private property owners and get permission to cross Indian Reserve lands. In 1972, shortly after becoming acquainted with the river, I wrote:

"The foreshore is an area of dramatic contrasts. Great blue herons fly over a timeless marsh, silhouetted against the black smoke of an industrial skyline. The feeble cry of the marsh bird is drowned out by the roar of modern jet engines. Twentieth century man stands on the riverbank with his charts and plans while the bones of the area's original inhabitants decay slowly, a few inches beneath his feet."

It is refreshing to stand on the riverbank today, nearly 20 years later, and see the parks and open spaces that have been created to bring people to the Fraser. The silhouette of the heron has a backdrop that is much improved and, as the region grows, it is turning once again to the river to refresh its spirit. You have a living river by your door. Discover it!

THE RIVER RESOURCE

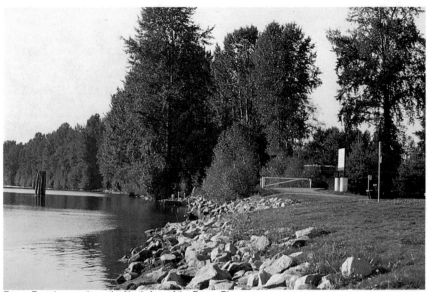

Fraser Foreshore park, on the North Arm of the Fraser River.

It begins as a trickle of glacial meltwater just west of the Continental Divide near Mount Robson. Joining with other small streams along the way, it begins flowing to the north with the appearance of becoming part of the Arctic Ocean drainage. As if deciding that this river should be destined for a greater purpose, a high piece of ground turns it away from its northward journey, and sends it hurtling southwest towards the Pacific. Recruiting other rivers to join forces, the Fraser begins to flex its influence by cutting a canyon through the Cariboo Plain. The Quesnel, the Nechako, and the Chilcotin all submit to the larger influence. Its turbulent brown waters completely devour the clear waters of the Thompson as it makes its way through the mountains that struggle to keep it confined. As if despising its confinement, it tears at the rock walls of the canyon in a fury of brown foam, climaxing at Hell's gate, where the waters boil through this 33 metre (110 foot) wide chasm at a rate of 977 million litres (215 million gallons) per minute- twice the volume that goes over Niagara Falls!

Then, as if spent by this violence, the river turns abruptly westward and trades its depth for width. Once again free to spread its mighty arms it slows its torrid pace and meanders across a wide valley, pausing along the way as if to ponder its own might. By the time it reaches the Strait of Georgia it has become one of the mightiest rivers in the world, over 1,378 kilometres (850 miles) long, draining over 238,000 square kilometres- an area larger than all of Great Britain. Peak flows at the river mouth reach 5 1/2 knots (over 6 mph). A yearly average of over 15,000 cubic meters of water pass between its banks each second, pushing a brownish plume dozens of kilometres into the clear blue waters of Georgia

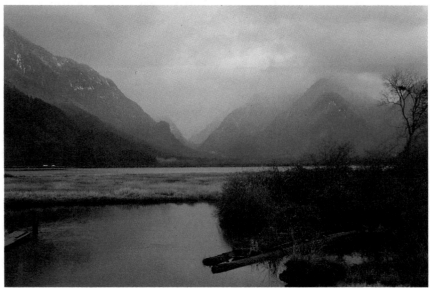
Widgeon Valley from across the Pitt River, a tributary of the Fraser.

Strait. Each year it carries with it over 20 million tonnes of sediment it has torn from the mountains and plains along the way. Its delta projects over ten kilometres (six miles) from the western dykes, and continues to extend the westward shoreline at a rate of three meters per year at sea level. Underwater, at the toe of the delta the shelf is building westward at an annual rate of eight meters. The Fraser actually reshapes the continent each year. The Fraser drops only about 30 metres (100 feet) in elevation on its 160 kilometre (100 mile) journey from Hope to the sea. Because of this, it is subjected to the effect of the ocean tides near the river's mouth. During low flow periods, some tidal effect can be detected as far east as Chilliwack. The average range of tidal influence is about one meter at New Westminster, where driftwood can be seen floating upstream as the tide rises in the Strait of Georgia. Boats navigating the Fraser use the tides to assist them in taking goods up or down the river. During the spring, when the greatest volumes of water occur, the flow is downstream along the entire river at all stages of the tide. About 80 per cent of the annual run-off occurs between May and July, a period called freshet. Its Lower Delta is the breadbasket that provides the bounty of natural resources that we enjoy and share with other creatures. Included in this are 80 species of fish that use the river for spawning, feeding, rearing and resting. Most significant of these are the five species of salmon. At any given time, at least one of the species is making its journey through the river. Over 800 million juveniles pass through this estuary enroute to the sea. They share the delta with over 1.4 million birds that migrate through, and about a half million others that depend on the marshes for food and shelter. It should be remembered that the Fraser, from its headwaters to the delta, is a totally Canadian river. All its beauty and natural values are in the hands of Canadians to manage. Its environmental health and destiny is also a Canadian responsibility. This magnificent delta that provides such a prolific bounty of natural resources also provides us with the variety of recreation experiences that are the subject of this guide. Its natural attributes

are an integral part of its recreational significance, and are woven into the tapestry that makes up the river and its estuary. The river's significant natural features are thus highlighted at the appropriate sites. From Hell's Gate to Boundary Bay, the Fraser River is one continuous recreation opportunity. This book highlights some of the more interesting opportunities, and celebrates its natural aspects. Recreation in this context is a blend of adventure and leisure time activity. It includes parks, open spaces, and interesting commercial and industrial activities that are part of the Fraser on its voyage to the Strait of Georgia, where it is finally swallowed by the Pacific Ocean.

REGION 1
THE NORTH ARM

The relatively shallow North Arm of the Fraser River stretches from New Westminster in the east to the Strait of Georgia in the west, a distance of about 24 kilometres (14.4 miles). It comprises about 10 per cent of the total flow of the Fraser River, and is undergoing a rapid transition from an area with a primarily industrial character, to one exhibiting many interesting and new personalities. The North Arm sites are as varied in their character as the North Arm itself. Sites covered in this section include river trails, estuarine marshlands, sandy beaches, the world's largest booming grounds, fishing bars, a boat launch and a public market. The new development, which includes a number of new parts and trails, is transforming the North Arm into a recreational destination worth discovering.

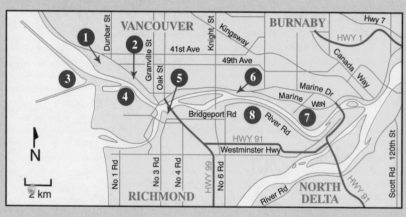

THE SITES

1. Southlands
2. Fraser River Park
3. Iona Beach Regional Park
4. Sea Island
5. Bridgepoint
6. Gladstone Riverfront Park
7. Fraser Foreshore Park
8. River Road East

Vancouver

 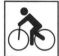

EASIEST ACCESS

Head south on Blenheim Street off 41st Avenue. Turn right at 53rd Avenue one block to Carrington Street and proceed south to the river. There is parking on the street, although construction is currently underway. Alternatively, head south on Dunbar off SW Marine Drive, turn right on 51st Avenue and park along the street, picking up the trail to the river from there.

Facilities: Parking
Trails

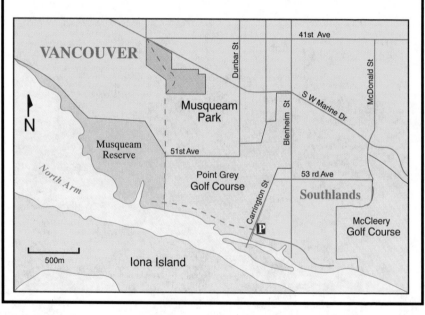

Southlands is a beautiful area stretching over four kilometres (2.5 miles) along the North Arm of the Fraser River. It's a great place for walking, cycling, picnicking, horseback riding or river traffic viewing. Immediately across the river, Iona Island offers a tranquil backdrop for the varied river traffic – barges, tugs, pleasure boats and fishing boats pass by in an endless procession. In the distance, aircraft can be seen coming and going from the Vancouver International Airport located on Sea Island.

Southlands is also one of Vancouver's most significant equestrian areas. Some of the southland dyke trails are owned by the Point Grey Golf and Country Club and maintained by the Southlands Riding Association as bridle paths. The trail, commonly called the Sawdust Trail, provides an excellent path for horseback riding, cycling and walking.

Deering Island, more commonly known as Celtic Island, is located where Carrington Street intersects with the river. Residential development of the island caused some destruction of the river marshland; consequently, the developers, under the new Federal Fisheries regulations, were required to replace lost habitat. As a result, a small but significant marsh area has been successfully created just west of the island.

Deering Island was once the site of one of the earliest canneries on the North Arm, dating back to the 1890s. In 1902, the Celtic Cannery merged with B.C. Packers to become one of the major canneries on the North Arm. A shipyard was built to maintain the boats of the packing company. Unfortunately, all of the historic buildings have been taken down to provide space for a major new housing development. There is a small public park at the western tip of Deering Island.

There is limited parking at the end of Carrington Street, and from here the dyke trail follows the river westward. This trail is used frequently by people on horseback or people walking dogs. The path parallels the river bank with a marsh and sand bar and Point Grey Golf Course. At low tide the sand bar is used for beachcombing and picnicking. During the late summer, watch for ripe blackberries on the bushes alongside the trails.

The dyke continues west as far as the Musqueam Indian Reserve, where Simon Fraser, the explorer, landed in 1808. While working for the Northwest Company, Fraser finally realized that the river he had been following for months was not the Columbia but another major river, which was later named after him. Today, the mud flats at the mouth of the North Arm are the site of the largest log booming grounds in the world.

At the westerly end of the path, the trail swings north between the Musqueam Reserve and the Point Grey Golf Course and intersects with several roads, including 51st Avenue, where roadside parking is available. The trail meanders behind a residential area for most of the way, with Musqueam Creek paralleling the path to the edge of Vancouver's Musqueam Park. The trail ends at the intersection of 41st Avenue and South West Marine Drive. From here you may want to cross Marine Drive and explore the extensive trails of Pacific Spirit Regional Park. Formerly called the U.B.C. Endowment Lands, this park has over 48 kilometres (29 miles) of trails that wind throughout its forested section. The trails are heavily used for walking, cycling and horseback riding. Although the majority of the park is not on the river itself, there are spectacular views of the Fraser Delta, and trails that lead to Wreck Beach at the mouth of the North Arm.

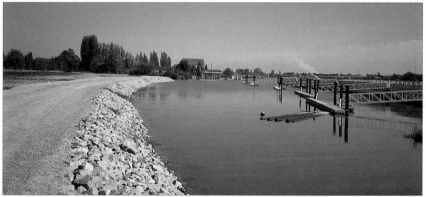

The former Celtic shipyard marina awaits the arrival of private yachts at Deering Island.

2 FRASER RIVER PARK

Vancouver

EASIEST ACCESS

From SW Marine Drive, near 70th Avenue, turn south (left if heading west) on Angus Drive. There are signs on Marine Drive and on Angus Drive to direct you to the park.

Facilities: *Information kiosk*
Viewing platform
Trails
Washrooms
Parking

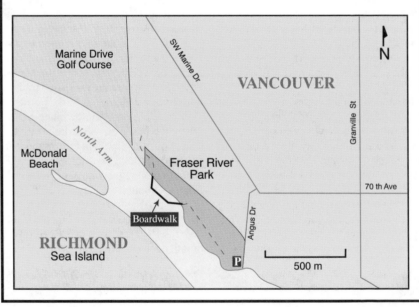

For many years there were no parks along the North Arm of the Fraser River. This part of B.C.'s greatest river was dominated by sawmills, fishing boats, canneries and heavy industry. Public access to the water is a commodity, usually limited to street-end road allowances required by law. The redevelopment of the Fraser is resulting in a turnabout, where the river is at our front door rather than our back door.

Vancouver's Fraser River Park is a great example of how recreation and commercial industry can co-exist. This 10.9 hectare (26.9 acre) park is strategically located near the south foot of Angus Drive near 75th Avenue. An interpretive display at Fraser River Park takes advantage of its proximity to the busy mouth of the river and highlights the numerous river activities in this area.

To accommodate the great number of

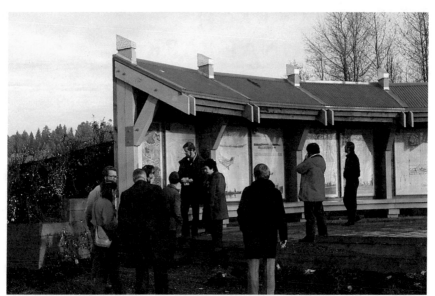

The interpretive display is a good place to learn about river history and ecology.

people who want to get closer to the river, the Vancouver Parks Board has provided pathways, an information display, viewing deck, washrooms and a parking lot for about 25 vehicles. The park has signs and displays that highlight the industrial and commercial aspects of the Fraser, providing an interesting opportunity to expand one's knowledge of river industries in a recreational setting. Fraser River Park is a good example of how recreation on this working river is being re-defined.

Another attraction of the park is a boardwalk that allows the visitor to walk right out over the Fraser Estuary, regardless of tide level, without interfering with the fragile marshland. It is an excellent location for viewing the natural river estuary ecosystems up close. The Parks Board, in conjunction with the Federal Department of Fisheries and Oceans, designed the boardwalk to ensure that both the recreation and

conservation aspects of the river were accommodated. The viewing platform is also a great place to observe the boats that continually pass by this spot towing log booms to mills farther up the North Arm, or pulling barges across the Georgia Strait to pulp mills on Vancouver Island.

The park has a large grassed area that is great for picnics and large enough for setting up a volleyball or badminton net, throwing a frisbee or playing a little soccer. A display near the parking lot provides information about the river, to examine before you start your walk. Large colourful displays describe the river and provide a brief outline of the habitat and wildlife you might see on a visit to this site. Interpretive signs along the trail give specific information about various aspects of the river resource. Fraser River Park is an ideal spot for Vancouver residents to learn about the Fraser Estuary and how it works for recreation and industry, and the wildlife habitats.

Richmond

EASIEST ACCESS

From Bridgeport Road westbound in Richmond, travel over the Sea Island Swing Bridge and turn right onto Grauer Road at the first intersection after the bridge. Continue parallel to the airport runway, then turn right onto MacDonald Road, then left onto Ferguson Road, past the Iona Island Sewage Treatment facility. The parking lot is at the end of the road.

Facilities: Parking
Washrooms
Picnic tables
Footpath
Cycle path
Viewing towers

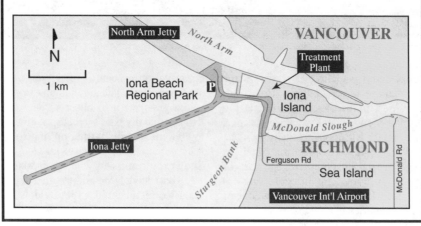

The need to stabilize a channel through the meandering delta at the mouth of the North Arm prompted the construction of the North Arm Jetty of Iona Island between 1914 and 1917. It was a rock wall, built to divide the river, that created the sand and mud flats that are known today as Iona Island. The North Arm Jetty forms the northern boundary of Iona Beach Regional Park.

The most unique experience at this park, is on the southern Iona Jetty. The GVRD Parks Department has created a surfaced pathway on top of one of Vancouver's major sewage outfall pipes. This unique walkway and paralleling cycle path extends four kilometres (2.5 miles) to the southwest towards the Strait of Georgia, creating an opportunity unlike any other in British Columbia.

The island's sandy beaches are ideal for picnics and sunbathing. The park area is only 30 hectares (74 acres), but at low tide thousands of acres of beach are uncovered to enjoy. The actual outfall extends well beyond the jetty and the waters are cleaner than at most city beaches. The sand flats are a great place for kite-flying, swimming and beach activities. The jetties that contain the beaches create calmer waters, safe for canoeing and kayaking. Note that activities are unsupervised, so common sense regarding weather and sea conditions should be exercised.

Sometimes seals can be seen sunning themselves along the rocks or at the end of the jetty. They are usually quite at home in the company of quiet observers and can be very entertaining.

The shore behind the beach is sandy and flat, while the island's south shore is predominantly river marsh. A very large number and variety of birds inhabit the lagoons, tidal flats, marshes and fields of Iona Island. Iona Island has one of the most concentrated populations of songbirds and sandpipers in the region. Consistently, the highest annual Christmas bird count in Canada is here. Ducks, geese, loons, grebes, blue and green-winged teal, mallards, great blue herons, ruddy ducks, gadwall, shovelers, pintails and several species of owls are commonly seen here in addition to the largest numbers of B.C.'s rare birds. Be sure to take your binoculars!

The master plan for Iona Beach Regional Park calls for a number of improvements to the site. In addition to more parking area and trails, viewing towers, washrooms, interpretive signs and intermittent rest areas along the jetty, the freshwater ponds near the staging area will be further enhanced with nesting islands, marsh planting and wildlife

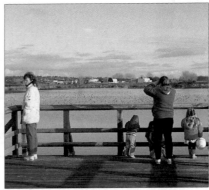
Thousands of waterfowl take refuge in the lagoons on Iona Island.

viewing towers. Viewing areas and washroom facilities are also provided at the end of the jetty.

Iona Island was originally called Mole Island after Henry Mole, one of the first settlers who arrived in 1864. It was renamed McMillan Island after another pioneer settler, Donald McMillan. McMillan himself later renamed it "Iona" after an island of the Inner Hebrides in his native land, Scotland. The Iona Sewage Treatment Plant is located on the eastern part of the island. Tours of the treatment facility can be arranged by calling GVRD at 432-6200.

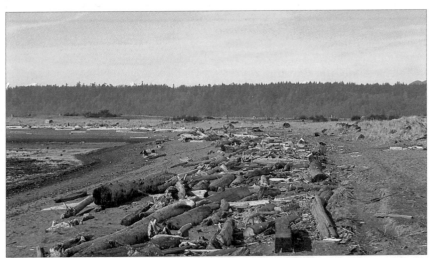
Driftwood litters the shores of Iona Island, with Pacific Spirit Regional Park in the distance.

4 SEA ISLAND

Richmond

EASIEST ACCESS

Take Sea Island Way west of Bridgeport Road in Richmond, cross the Sea Island Bridge over the Middle Arm and make an immediate right turn, heading north towards Grauer Road. You can park under the Arthur Laing Bridge and walk the five kilometre (3 mile) river trail, or proceed west on Grauer Road to where it veers north and becomes McDonald Road. Here signs will direct you to McDonald Beach Municipal Park.

Facilities: Boat launch
Washrooms
Picnic tables
Playing field
Parking

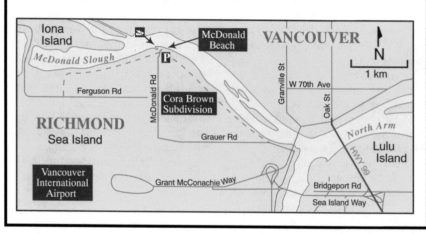

The best place to take advantage of the recreational features of Sea Island is the area on the North Arm known as Woods Island or McDonald Beach Municipal Park. At one time Woods Island was separated from the larger Sea Island, but alluvium from the Fraser River and dykes have connected the islands, leaving Woods Island an island only in name. McDonald Beach has a boat launching ramp with boat-trailer parking, one of the very few on the Lower Fraser. There is a daily fee for parking and launching; season passes are available from the caretaker. There are washroom facilities, picnic tables, parking for over 100 cars

and a large grass playing field. McDonald Beach runs along the north shore of the island. The eastern end has some beautiful dunes and beach areas, making it popular for sunbathing and beachcombing and fishing on this 2.6 hectare (6.4 acre) municipal park. Across the channel to the north is Vancouver's Southlands.

McDonald Beach is located midway along a dyke trail. The trail extends from the west end of Ferguson Road, near the Iona Island causeway, to the east end of Sea Island. This five kilometre (three mile) gravel path is ideal for walking, cycling or horseback riding. The dyke provides interesting views of the river,

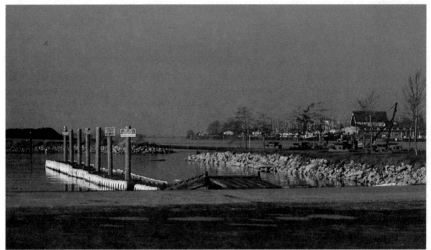

The boat launch at McDonald Beach is a popular place to launch a boat on a scenic part of the river.

where barges, tug boats with logbooms, pleasure boats and fishing boats all vie for passage along the narrow waterway. The protected waters of McDonald Slough, though filled with logbooms, are very good for kayaking and canoeing. Paddling along you are sure to see a variety of shorebirds, including gadwall and widgeon.

One of the more interesting ways to get to the north shore of Sea Island is to drive or, better yet, walk or cycle through the abandoned Cora Brown subdivision located between Grauer Road, McDonald Road and the North Arm dyke. Between 1963 and 1973 land was expropriated for the expansion of the Vancouver International Airport. The northern portion of Sea Island remains open to the public.

A thriving farming community that once existed here has left a rural legacy reflected by overgrown fields, old fences, hedges and the occasional abandoned farm building. The abandoned streets create a safe and scenic cycling or walking excursion. Wild-flowers growing along the ditches emit their perfume into the air during the summer. The hedgerows are alive with birds and small mammals and dense populations of hawks and owls are found along Grauer and

Ferguson Roads. Great blue herons and pheasants are also common.

Sea Island has a long history. Captain Richards of the Royal Engineers coined the name Sea Island in 1859. At that time the island was undyked making it difficult to determine the land from the sea. Hugh McRoberts, drawn by the island's serenity and beauty, acquired nearly half of the island in the 1860's. He cultivated fruit, wheat, and vegetables and later herded cattle. At one time the McRobert's farm was reputed to be the largest in the British Empire. According to some, Sea Island reminded Hugh's daughter, Jennie. She renamed Sea Island *Richmond View* after her birthplace in Australia.

Bridges were built over the North Arm of the Fraser in the late 1800s. Because of easier access, Vancouver storekeeper, Harry Eburne moved his business to the northeastern point of Sea Island, where in 1894 the Eburne Post Office was established. Grauer moved later and established a store and post office on the island around 1913. The Grauer store, for decades a landmark on Sea Island, is gone — as are many of the original farms and commercial buildings that once sheltered the hardy pioneers who settled the Fraser Delta.

5 BRIDGEPOINT

Richmond

EASIEST ACCESS

Head west on Bridgeport Road in Richmond to Number 3 Road (Charles Street). Head north on Number 3 Road to the parking lot for the market complex.

Facilities: Parking
Shopping centre
Restaurants
Washrooms

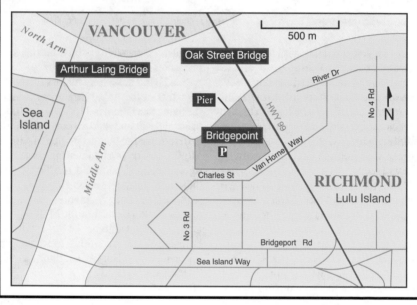

Bridgepoint Quay, located near the junction of the North and Middle Arms of the Fraser, is an interesting blend of commercial, recreational and natural features. A walkway takes the visitor out over the North Arm, past extensive cat-tail marshes on one side and a modern marina on the other. The market sells fresh produce and seafood, and contains many specialty shops. There is a great view of both the Arthur Laing and Oak Street Bridges; the boat traffic is especially noticeable here at the river junction.

The front doors of the market building lead to a large foyer where a mechanical clock tells not only the time, but the phase of the moon and the tides. It is fascinating to watch its pendulum, wheels and cogs in perpetual motion. The east wing of the building is a shopping centre containing mainly specialty stores and craft shops. The west wing, an open market place, is a cornucopia of sights and smells. Pyramids of ripe strawberries stand beside bundles of asparagus standing at attention, joining other crisp

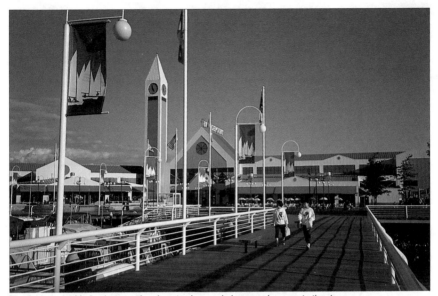

The Bridgepoint Market is a popular place to shop and gives good access to the river.

vegetables and colourful fruit. They give the air a sweet mildew scent. On the sweets side, mountains of soft fudge or peanut brittle are mixed on a large marble slab while fresh pasta churns from a mill. The exotic aromas of coffee and tea, fresh baked bread and pastries fill the air. Homemade ice cream and candy shops are always busy. Seafood vendors sell fresh fish and shellfish from their boats. Shopkeepers sell their wares with pride and with attention to detail that complements the market atmosphere.

A food fair on the north side of the building offers a wide variety of both ethnic cuisine and fast food.

On the large wooden deck there are numerous tables and benches with a view of the North Arm. The industrial activity across the channel provides constant action. A walkway extends from the deck to the marina, where a ramp leads down to the river. Both fishing and pleasure boats dock here. Visitors can take tour boat excursions along the North Arm. West of the walkway, a small area of marshland that has been preserved supports a surprisingly large number of

waterfowl, particularly ducks, which stay in the marsh all year round.

Part of the overall plan for Bridgepoint is to extend the marsh and to develop a larger park area to surround it. A new restaurant and hotel are being constructed on the east side of the market area. Bridgepoint is another example of how industry (across the river), commercial development (the quay), and wildlife habitat (the marsh area) can co-exist in harmony at one location if planned with multiple use in mind.

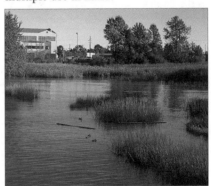

The pier at Bridgepoint gives access to a marsh area that is one of the key natural attractions of the market.

6 GLADSTONE RIVERFRONT PARK

Vancouver

EASIEST ACCESS

Heading east or west on South East Marine Drive, turn south on Victoria Drive. Signs will direct you to the parking area at the

Facilities: *Parking*
Trails
Fishing pier
Viewing deck

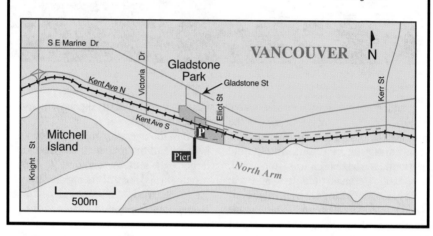

Amidst the heavy industrial areas, dense business districts and residential areas, street-end parks create points of access to the contrasting fluid movements and sounds of the river. Even the narrow trail between the river and the railway tracks or roads lining the riverbank can create opportunities to escape the rush and get closer to the river that threads its way like a ribbon through the region.

Once just a street-end access point, the Gladstone Riverfront Park is an urban oasis worth a visit, especially if you live in the city. This small linear waterfront park is extremely popular for walking and river viewing amongst local residents, whose numbers are increasing daily as more and more homes appear on Van-

couver's south side. These new homes are replacing the industrial skyline that once dominated the Fraser lands.

At the foot of Gladstone Street, where it meets the North Arm of the Fraser River, there is a cul-de-sac that can accommodate about 12 cars. A pier extends over the river where one can view the smooth curves of the Knight Street Bridge, watch the river traffic or cast for salmon. There is also a grassed area with a wooden bench facing the wharf; the wharf has a viewing platform.

A river front trail runs from Argyle Street to Kerr Street. The path, which runs for about 1.5 kilometres (1 mile) from the parking area at Gladstone Street, is picturesque as it meanders along the